Wilderness *to* Water

TOM GRAFFAGNINO

Printed in the United States of America by BookMasters, Inc
Ashland, OH
October 2014
50006798

Rev. date: 05/27/2014

To order additional copies of this book, contact:
Xlibris LLC
1-888-795-4274
www.Xlibris.com
Orders@Xlibris.com

TABLE OF CONTENTS

Preface

The sacrifices of God are a broken spirit; a broken and contrite heart, O God, you will not despise.

—Psalm 51:17

* * *

I began to draw and paint—to *seriously* draw and paint—in the early spring of 1971 at the age of twenty-two, a senior non-art major at Tulane University in New Orleans (see Prologue). It was also the same year and season that the seed of my Christian faith was pressed into my heart. And not coincidentally, it was also the same year and season that my love for Ann Marie McCormick blossomed as well.

I asked Ann to marry me that spring. Thankfully, she said yes, and we were married in July.

In the spring of 1971, I experienced God's grace, God's mercy, and God's blessing in my life. It was an emotional and spiritual turning point for me, a turning point for which I am eternally grateful. That spring, God gave me a talent, a direction, a vision, and a purpose. He gave me a graciously patient, loving, and supportive wife. The Lord also gave me an awareness of his real and living presence in my life, as well as a longing to know and understand Him better.

In 1971, the Lord set Ann and me on a path and a journey that lasted for thirty-six years. Along the way, He blessed us with two wonderful children, Patrick and Maria, and with wonderful family memories too numerous to recount. He coaxed, nudged, and prodded as He guided me through years of productive, creative effort. He was with me as well through the unproductive valleys of creative frustration. I knew and trusted that Jesus was present with me and was somehow behind it all (even during the low periods), but I did not know Him as my Savior and my Lord until 1993 when, at the age of forty-four, I came to trust Him truly and put my faith in his Word, the Gospel message of the Bible. (But that, perhaps, is a story for another time.)

On September 9 of 2001, Ann was diagnosed with colon cancer. Two days later, on the morning of September 11, as Ann was just beginning to recover from extensive surgery (the first of many surgeries, as it turned out), I watched the TV screen in her hospital room as the twin towers of the New York World Trade Center collapsed in a deadly cloud of dust

and rubble. I felt as if we had both been hit.

For the next six years, Ann bravely and gracefully endured the emotional struggles, the draining fatigue, the physical pain, the seemingly endless complications, and the personal indignities of the disease.

In the winter of 2005, during a period of remission, Ann told me that she thought that it would be good for us to travel to Israel, the Holy Land. For several years, a pilgrimage to Israel had been an unfulfilled dream of ours. And so we bought our tickets, joined a tour, and traveled to Israel in the spring. Despite the fact that Ann's lack of stamina made it impossible for her to participate in some of the more strenuous excursions, the trip nevertheless proved to be an unforgettable experience and blessing for both of us. I treasure the memories.

Our tour of Israel took us to Jerusalem, Nazareth, Megiddo, the Sea of Galilee, the Jordan River, Caesarea Philippi (Paneas), the Temple Mount, the Garden Tomb, and much more. But what stuck with me and impressed me the most about the entire trip was the Judean wilderness, the land east of Jerusalem. The bus ride down from Jerusalem to Jericho and the Dead Sea nearby struck a chord that reverberated within me. I could not shake it. The beautiful and intimidating landscape features set my spirit somehow on edge. I didn't understand *why* it had such a strong effect on me until a few years later.

In January 2007, the doctor visits, the complications, the operations, the countless chemotherapy, and radiation sessions ended for Ann when the Lord granted her eternal *Sabbath* rest in his glorious and merciful presence.

The years immediately after Ann's death were painful and difficult for me as I know they are for everyone who loses a beloved and treasured wife or husband. The mourning and grieving process is never easy. For me, it was like entering an emotion-numbing fog. A creeping depression quietly began to engulf me. It was a depression that I did not recognize or comprehend. I didn't realize the stifling influence and impact that my grief was having on me at the time. It was a lonely period, of course, but it was also a time of emotional confusion and duress. It was a time of doubt. I questioned my faith and began to drift away from the Lord. I wandered away from my church family. I drifted away from God's Word, the Bread of Life. I distanced myself from the Good Shepherd's voice and from his instruction and subsequently found myself staggering—physically, emotionally, and spiritually.

I found myself wandering in my own personal Judean wilderness—for the most part, a self-inflicted journey.

My faith was shaken after Ann's death. Looking back, I can recognize that, but at the time, I could not see it clearly. Somehow, through it all, I never doubted *God's* presence. I held on to the truth of *God's* faithfulness even as my own faith and commitment to Him were compromised and weakened and surely seemed to be slipping away. There were times when I knew that I was hanging on only by a thread. I later came to realize that the thread to which I clung was God's thread…not my own. I was not hanging on to Him; He was hanging on to me according to his promises:

The LORD your God goes with you; he will never leave you nor forsake you. (Deuteronomy 31:6)

Who shall separate us from the love of Christ? Shall trouble or hardship or persecution or famine . . . No, in all these things we are more than conquerors. For I am convinced . . . [that nothing] . . . in all creation, will be able to separate us from the love of God that is in Christ Jesus our Lord. (Romans 8:35–39)

Just as a good shepherd will seek his lost and thirsty sheep, God came after me. He carried me through the desert and brought me to the still and refreshing waters of an oasis pool. He brought me through a stark, dark wilderness valley and back again into His light.

For that, I am more than thankful.

This book is about my journey through the wilderness of grief and my struggle in the desert of doubt, fear, and depression. It is about God's faithfulness to me even as my own faith wavered. God brought good news out of bad and blessing out of struggle and pain. God understood, comforted, and refreshed. God chased the darkness with light, brought joy out of suffering, and gave hope when I saw no hope at all. When I was unable to turn the page in my life, God did it for me.

Four years after Ann's death, God richly blessed me a second time when He brought Jane Skelton, herself a widow, into my life. Jane and I fell in love, and three months after we met, we were married.

I have been twice blessed by a gracious and merciful God.

How I praise my God who delights in shepherding his children through the desert of this world to the shores of Living Water. I am eternally grateful for His amazing grace.

My prayer is that the thoughts and images recorded here may be both a reminder and an encouragement to those who might be facing difficult emotional and spiritual battles, battles that may seem insurmountable, perhaps even, at times, life-threatening.

* * *

I have known the rapture of the lonely shore and have partaken of the healing solace found in pathless woods. I know now, on a deep level, that polish comes through trouble and that not a single heartbreak in one's lifetime need go to waste. All things can be used of God to develop in a believer an unshakeable trust in Him. He is the Rock of Ages and I am confident that He holds me tight in the place cleft especially for me.

—Donna F. G. Hailson

Corrie Ten Boom observed, "No matter how deep our darkness, He is deeper still." And to that, I say, "Amen".

Introduction

As mentioned in the preface, this book is about God's merciful, open-door policy to the troubled and the despairing, those who, for a season, may find themselves wandering from the fold into the dangerous heat of the wilderness or staggering through the "backside of the desert." It is difficult to characterize or categorize the contents of this book. It is certainly autobiographical….. but not, I think, in the usual sense.

For the most part, it is a collection of essays, observations, and meditations about trial, affliction, and testing. It is also about God's grace and blessing that may follow. It is a record of my passage through a wilderness of ups and downs that lasted a decade, from 2001 to 2011.

In the twenty-third Psalm, David writes about passing through "the valley of the shadow of death," and in the same psalm, he writes about being led "beside quiet waters" where he is comforted and restored. This book is about *both* of those places, places that we all experience at one time or another in our lives. This book is about both the desert and the refreshing spring.

About the Drawings (2008–2010)

The charcoal drawings included in this book (Part One) were done between 2008 and 2010. These drawings are not depictions of specific locations. Instead, they represent an inner landscape, a "place" of emotional upheaval in my life. They are autobiographically illustrative, but they are not illustrations.

I think of the drawings as impulsively created visual footsteps through an inner terrain. As I was doing the drawings, I sensed that they were somehow cathartic in nature, but I did not understand exactly how…or why at the time.

I did hundreds of these small landscape drawings after Ann's death. I did them in needful frenetic spurts, as I recall. I never consciously set out to draw my impressions of the Judean wilderness of Israel, but I am, however, convinced that these images were conceived there when Ann and I traveled through that beautiful but daunting desert region of the Holy Land in 2005.

About the Photographs (2010–2011)

If the drawings may be thought of as representing visual footprints through a stark wilderness valley, then the photographs represent a time of leaving that valley behind and stepping into a cool, clear, sunlit, high pasture above and beyond the stifling heat. They represent a place of restoration, renewal, hope, and wonder.

The images became for me like once-shuttered windows that had been graciously flung open by the Spirit of God. They were spurs for digging deeper into the healing and boundless truths of God's Word and for discovering new treasures therein. In retrospect, I think God used the images to help put me on more solid ground.

Sometimes the photographs served as catalysts for the written thoughts, and sometimes, the thoughts served as catalysts for the photos.

Some of the photos taken at the water's edge may at first glance seem somewhat confusing. Many have told me that they assumed that these shoreline images had been photoshopped. But they are not photoshopped. (I don't know how to photoshop!) The images are simply interwoven and intersecting shoreline realities that are the water's surface, the surface *beneath*, and the reflections of things *above*.

About the Writing

I began to write the short essays and poems in 2011. They were simply thoughts about the charcoal drawings I had done earlier *and* about the photographs I had just begun to take. The writings here are essentially journal entries, attempts to verbalize both my state of mind and the condition of my heart as I searched the scriptures. They were efforts to understand and, perhaps, come to grips with a decade-long journey and a sometimes badly-stumbling walk with God. I suppose the writings were a kind of poor man's effort at self-examination and self-analysis. I discovered that during the process of trying to put my thoughts down on paper, I would often fall into a mode of meditative prayer and thanksgiving to God for the "shepherding" graces He had granted me through the trials of the previous years.

I did not set out to write a book. The contents simply seemed to accumulate. I found that the drawings and the photographs were telling a story. I tried to sort through and fill in the blanks by writing.

The Purpose

My prayer is that the images, the writing, the quotations, and the scripture verses that I have chosen to present here may be an encouragement to some. I also pray that the words and the images may stir others to wonder and to honestly and prayerfully seek the One who claims to be the Life, the Truth, and the Way, the One who has revealed himself in and through the Bible and also through the awesome design and intricate beauty of nature—the endless, sensation pleasing landscape masterpiece of his creation.

If there be just one who, because of what is written here, might choose to sincerely seek the truth, to knock, and to ask, then to God be the glory.

* * *

Ask and it will be given to you; seek and you will find; knock and the door will be opened to you. For everyone who asks receives; he who seeks finds; and to him who knocks, the door will be opened.

—Matthew 7:7–8

I, for one, have found the God of Abraham, Isaac, and Jacob to be the most excellent of promise keepers. And while I have certainly not learned to trust Him perfectly, I have learned to trust Him more and more even when life hurts.

Eugene Peterson, in his introduction to the book of Isaiah *(The Message)*, observes that:

the stuff of our ordinary and often disappointing human experience . . . is the very stuff that God uses to create and save and give hope. As this vast panorama opens up before us, it turns out that nothing is unusable by God. He uses everything and everybody as material for his work, which is the remaking of the mess we have made of our lives.

I concur.

Prologue

One evening in 1971, at the age of twenty-two, I sat down with a friend who (with a twinkle in his eye as I recall) showed me several color-plate reproductions in an art-history book. They were photographs of the intricately hand-painted, illuminated manuscripts of the four New Testament Gospels in *The Book of Kells,* an artistic masterpiece created by Celtic monks around AD 800. I was astounded and quite literally awestruck at what I saw.

At that moment, I distinctly remember wondering and asking myself a series of questions:

What on earth could possess a human being to create such marvelous and intricate images?

How on earth could such intensity of purpose and profound dedication, sacrifice, and love find expression like this?

How? I wondered. *Why?*

What in heaven's name is going on here?

And then, of course, it dawned on me. The answer to my *How?* to my *What?* and to my *Why?* was a Who—*a Person.*

That night was a revelation for me. A desire to draw and paint was planted in my heart. The seed of faith in Christ was planted there as well.

* * *

Someone once observed that the natural universe, the creation around us, is "a kind of corporeal and visible Gospel." I believe that is true.

Nearly 2,000 years ago, the apostle Paul wrote,

For since the creation of the world God's invisible qualities—his eternal power and divine nature have been clearly seen, being understood from what has been made so that men are without excuse. (Romans 1:20)

I am convinced that nature—all that we see around us, all living things, the waters, the earth, and the heavens above—is a God-conceived, marvelously integrated tapestry woven together for our consideration, created and designed to bring Him glory.

Likewise, I am convinced that the natural universe that we encounter with our senses may be understood as God's initial self-disclosure, a primer—a *first edition prologue text* of a magnificent and dramatic story unfolding before us. This "prologue" of nature beckons universally to every human heart and soul just as surely as the ancient manuscript illuminations invited the reader to enter the sacred Gospel texts.

The twelfth-century Christian mystic Richard of St. Victor wrote that "the whole of this sensible world is like a book written by the finger of God." If those words are true—as I believe they are—then, perhaps, we ought to earnestly and sincerely seek a deeper knowledge of this world's Author and Creator. We ought to do so not *only* through the "word" of nature's pages (what theologians call *general revelation*), but we also ought to seek to know Him in and through the verbally communicated Holy Scriptures, the prophetic, *spoken* Word, what theologians refer to as *special revelation:* the Bible.

I am persuaded that we are daily being invited to read *beyond* the elegantly complex and beautifully written divine prologue of nature. We are freely encouraged to press on to discover the rest of the story, the *special* revelation, the greatest story ever told.

> In the beginning was the Word and the Word was with God and the Word was God. He was with God in the beginning . . . The Word became flesh and made his dwelling among us. We have seen his glory, the glory of the One and Only who came from the Father, full of grace and truth. (John 1:1–2, 14)

<p style="text-align:center">* * *</p>

Without-Excuse Creation
(Love-Letter Declaration)

Father, help us read your message
In the forest and the trees;
Help us take note in the margins
When we feel your gentle breeze.

Then, Lord, help us read the pages
Of your manuscript at night
When we wonder at the heavens
And eternal endless light.

This creation letter's written
From your heart and from your mind;
May we not dismiss your missive . . .
Help us read between the lines.

Please *illuminate* the story
You've spelled out before our eyes...
If we're hiding in the Garden,
Strip away our thin disguise.

Your "Without Excuse Creation"
Speaks to every human soul.
Draw us into your narration . . .
Tell us how your plot unfolds...

Help us move beyond the prologue
Help us turn another page . . .
Walk us through that Gate of Glory
To the Kingdom's coming age.

* * *

The eternal light is proclaimed to the world in two ways, namely, Scripture and Creation . . . [The] first step in climbing the heights of virtue is the letter of Holy Scripture and the appearance of visible things, so that once the letter has been read and creation examined, they may ascend, by the steps of correct reason, to the spirit of the letter and the rationality of creation.

—John Scotus of Erigena (ninth Century)

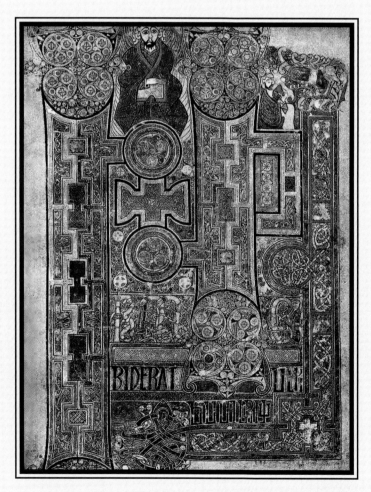

Book of Kells (illuminated manuscript, The Gospel of John)

PART ONE

WILDERNESS

In the Old Testament scriptures, the word *wilderness* is found more than three hundred times. The word is used more often than not to describe a dry and rugged landscape. But the Hebrew word (*midbar*) suggests more than that, really. It does not *just* mean an arid, barren *physical* environment. Its meaning is much fuller and richer.

In the Hebrew, the word actually suggests an area through which sheep are *led* by a shepherd. That is, it suggests not just a desert, but a kind of rugged *passageway-to-pasture* where instruction is *arranged* and guidance is provided. Indeed, the primary root word from which it (wilderness/*midbar*) is derived is *dabar*, a word that means *to subdue* for the purpose of teaching and instructing as, perhaps, a good shepherd might arrange to discipline and instruct his sheep for their benefit and good while leading them to pasture and to life-sustaining water.

From a human perspective, throughout the scriptures, Old and New Testaments alike, the desert wilderness was most often a place of testing and trial. It was a lonely place of anguish, grief, and disappointment, a place of aimless wandering, doubt, complaining, and bitterness. It was also a place of pressure and suffering. For the wandering Jews who followed Moses out of Egypt, the desert wilderness meant temptation, rebellion, and idolatry. In a word, the wilderness engendered *sin* even as it promised a vision of freedom. It was a place of *exposure* where spiritual weakness and lack of faith were uncovered and laid bare for all to see. It was a place where the heat of The Law bore down upon them just as relentlessly as the scorching sun.

The wilderness was and is an imposing place of confrontation.

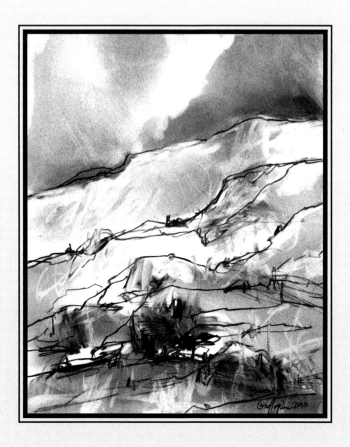

But there were also hiding places in the wilderness—pockets of refuge and quiet caves of solitude, dark places for reflection and self-examination. The desert is described in scripture not just as a place where trial and pressure is endured but also as a place for learning patience and perseverance, refining and growing, a place for digging deeper. It is also described as a place where true *revelation* was delivered.

The prophet Isaiah spoke of this aspect of the wilderness experience when he wrote that it would be a place where "the eyes of the blind shall be opened and the ears of the deaf unstopped" (Isaiah 35:5).

In the Bible, Moses, Elijah, David, John the Baptist, the apostle Paul, Jesus, and others all had profound and difficult experiences in the desert, experiences that helped in equipping them to fulfill their divinely appointed purposes and tasks. The biblical wilderness was not only a place of tribulation and suffering. It was also a place of testing, benefit, and hope.

And, Lord, may it be for all of us as well.

Lord, We Know You Use the Desert

Lord, we know You use the desert
And the wilderness of pain….
It's your crucible for grinding
And exposing sinful stain.

Did you take Paul to the desert
To inform his heart and soul?
Did You give him there instruction?
Did You make him there more bold?

And of Jacob, Father, tell us
Of that lonely desert fight,
How You wrestled with your servant
Through the darkness of the night.

In the burning desert wasteland
John the Baptist heard the call,
It was there the herald sounded,
There the Levites were appalled.

It was there where God found Moses…
It's where God proclaimed The Law;
It was there He forged a nation,
Through the pain and through the awe.

It was there that Christ was tempted
And it's where the devil lies…
In the wilderness of heartache
And our weakness amplified.

In the wilderness of sorrow,
Through the hurt of years gone by,
God is seeking his beloved…
Those whose wells have all run dry.

* * *

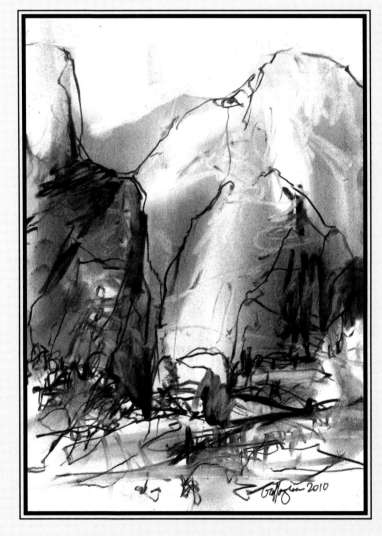

THERE'S A WHISPERED TRUTH IN HIDING

When we falter and fall in the wilderness, God promises to sustain and lead us through the barren terrain, through the heat of emotional stress, through the grays of doubt, and through the pitch blacks of despair. All too often, we are ensnared in our own idolatrous traps. Even though we may dig our own pits (and then curse God after we have fallen into them), He is still willing to rescue and restore us. When we find ourselves bruised and hurting in a "Judean wilderness" of our own making, beaten down and robbed by deceiving spiritual forces that prowl around us, He is there. When we find ourselves reaping the consequences of our own foolish rebellion, despairing and struggling in a "far country"—like the prodigal son in the Gospel of Luke—our merciful, gracious Father God remains faithful and is there to guide us home.

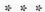

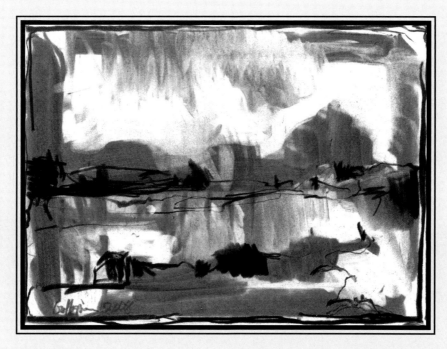

There's a Message in the Desert

There's a message in the desert,
Purpose hiding in the pain,
There's a lesson for the seeker
And a gift therein contained.

Through the wilderness we wander,
May we hear the Shepherd's voice…
May this passage, Lord, be fruitful,
At the end, may we rejoice!

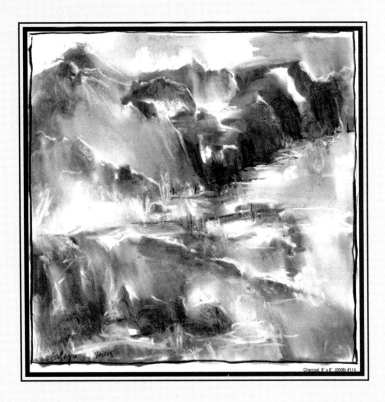

Charcoal, 8" x 8", (2008) #114

There's a reason for the pressure
In this wilderness of heat…
There's a reason for the furnace,
In each life still incomplete.

There's a whispered Truth in hiding
In each trauma that we've known,
There's a lesson there worth learning,
There's a seed that must be sown.

There's a reason for the heartache,
There's forgiveness for the past…
There's a Light beyond the mountain
And a Blessed Hope at last.

There's a reason for the wand'ring
Through each desolating gorge,
Heaven, help and give us comfort
While the Truth in us is forged.

BARTIMAEUS

In the days of Jesus, there was a winding path that ran through the Judean wilderness from the holy city of Jerusalem eastward to the town of Jericho—a distance of less than twenty miles. The road to Jericho was notoriously dangerous. Brigands, robbers, and thieves were common on the road. The parable of the Good Samaritan, which Jesus told, took place on the Jericho Road.

This road between Jerusalem and Jericho wound its way through some of the most desolate and inhospitable terrain in the world- rugged, rocky, dry, and hot. It was…and still is…a mountainous, barren desert wilderness. But there is more….

The road from Jerusalem to Jericho not only ran east and west, it also wound *down.* Essentially, the town of Jericho was (and is today) situated on the plains of the Dead Sea at the bottom of what is known as the Great Rift Valley, the lowest region of land on the planet some 1,400 feet below sea level. (In fact, this region is five times lower than California's Death Valley.) By contrast, Jerusalem, Israel's historic capital and religious center, is situated some 2,500 feet above sea level. The drop from Jerusalem to Jericho and the Dead Sea is breathtakingly precipitous.

As you can imagine, the trek through this "wilderness" from Jericho up to Jerusalem is arduous and grueling. It was an exhausting and dangerous journey. If the thieves and the scorpions and the vipers did not get you, the heat and the thirst from the climb certainly would.

It was here in this same desert area that Jesus was tempted by Satan immediately before his supernaturally empowered earthly ministry began (see Luke 4:1–13).

It was also on this Jericho Road that Jesus began his final climb up to the city of Jerusalem. It is where Jesus encountered a blind and wretched beggar named Bartimaeus (a name meaning "the son of the unclean and defiled"). Destitute, blind Bartimaeus, a man "poor in spirit"—if ever there was one—was a man who lived on the wilderness plain of the Dead Sea.

Then they came to Jericho. As Jesus and his disciples, together with a large crowd, were leaving the city, a blind man, Bartimaeus (that is, son of Timaeus), was sitting by the roadside begging. When he heard that it was Jesus of Nazareth, he began to shout, "Jesus, Son of David, have mercy on me!" . . . "What do you want me to do for you?" Jesus asked him. The blind man said, "Rabbi, I want to see." "Go," said Jesus. "Your faith has healed you." Immediately he received his sight and followed Jesus along the road. (Mark 10:46–52)

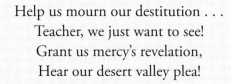

On This Road from Jericho

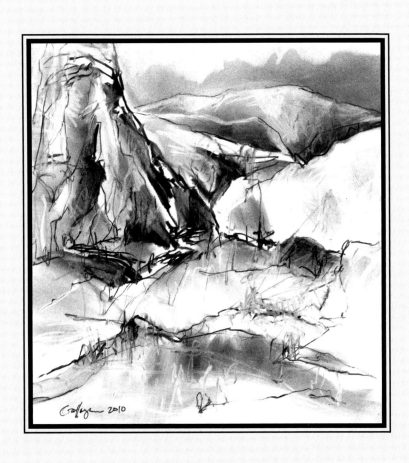

Help us mourn our destitution . . .
Teacher, we just want to see!
Grant us mercy's revelation,
Hear our desert valley plea!

Give us sight like Bartimaeus . . .
Be the lamp unto our feet.
Lift us high from barren badlands,
Give us shelter from the heat.

In this wilderness, be with us . . .
Be our resting place and shield.
Be our spring of Living Water,
Bind our wounds until we're healed.

Grant us grace to recognize You . . .
Help us see that we are blind,
Help us see we're unclean beggars,
Grant that we your mercies find.

Rescue us from highway brigands,
In your presence, may we hide.
Help us, Lord, to climb
this mountain . . .
And with You, let us abide.

Though we stumble, call us higher . . .
Though we falter, Lord, come near!
Guide each step that lies before us,
Lord, make our direction clear.

Take us from this Dead Sea shoreline . . .
Be The Way for us to go...
Help us follow You to Calv'ry
On this road from Jericho.

* * *

If we do not see that we are a mass of pride, ambition, lust, weakness, misery and injustice, we must be very blind. And if, once we know it, we do not seek deliverance from them, what can we say of man?

—Blaise Pascal

* * *

It is not the healthy who need a doctor, but the sick. But go and learn what this means: "I desire mercy, not sacrifice. For I have not come to call the righteous, but sinners."

—Matthew 9:12–13

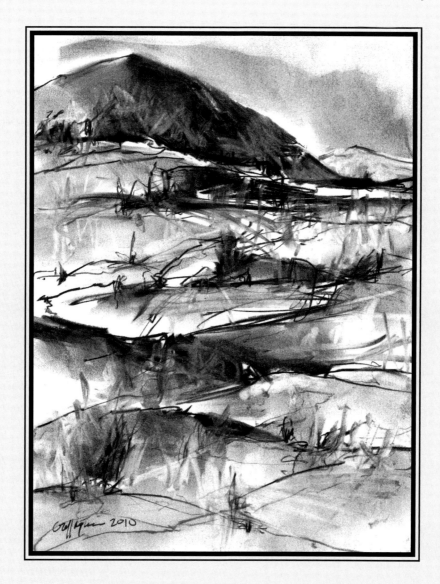

MOSES AT THE BURNING BUSH

Now Moses was tending the flock of Jethro his father-in-law, the priest of Midian, and he led the flock to the far side of the wilderness and came to Horeb, the mountain of God. There the angel of the LORD appeared to him in flames of fire from within a bush. Moses saw that though the bush was on fire it did not burn up. So Moses thought, "I will go over and see this strange sight—why the bush does not burn up." When the LORD saw that he had gone over to look, God called to him from within the bush, "Moses! Moses!"

And Moses said, "Here I am."

"Do not come any closer," God said. "Take off your sandals, for the place where you are standing is holy ground." Then he said, "I am the God of your father, the God of Abraham, the God of Isaac, and the God of Jacob." At this, Moses hid his face, because he was afraid to look at God.

—Exodus 3:1–5

* * *

Moses resisted God's call on his life. Time after time, Moses put God off. Moses was a most reluctant convert and an even more hesitant follower. Moses was also a murderer and a fugitive from his past in Egypt. He fled for his life into the Midian desert wilderness.

We, like Moses, often try to run away from our past, our transgressions, our iniquities, and our sins. We try to bury our guilt from hurting others just as we also paper over our unwillingness to forgive when others have hurt us. Whatever the case may be, we all have *unresolved* issues that plague us and cause us strife and pain, issues that we desperately want to leave behind, sweep under the rug, and forget. If these issues remain unaddressed and unresolved, they continue to plague us and keep us from living our lives productively in service to God.

In the book of Exodus, Moses may have thought that he had found a safe haven in the wilderness of Midian (from the Hebrew word *midyan*, meaning *strife* and *contention*). I am quite sure he thought that his Egyptian "baggage" was behind him and that he would no longer have to *contend* with all the conscience-grating unpleasantness of his past offenses against man and God. And yet, there in a stark and barren land that was named Strife and Contention, Moses was confronted by a Holy God in a burning bush. There in the shadow of Mount Horeb (Sinai), Moses stepped into the awesome presence of Holy God, and the false comfort of the Midian wilderness went up in smoke. He discovered that God is not so easily sidestepped or avoided. We are, after all, ultimately accountable to *God's* standard of holiness—not our own. A righteous God, sooner or later, will hold our feet to the fire of his holiness and command us to "take off our sandals." Ultimately, truth and justice demand it.

And if God deems it necessary to take us to the land of Strife and Contention to gain our attention, He will.

We may balk and stammer as Moses did at the divine confrontation in our own personal "land of Midian," but God will have his way. Discipline is never easy. The writer of the epistle to the Hebrews gives us this word of advice and encouragement:

My son, do not make light of the Lord's discipline, And do not lose heart when he rebukes you, because the Lord disciplines those he loves and punishes everyone he accepts as a son. (Hebrews 12:5–6)

Ultimately, the wilderness serves a good, just, and loving purpose, whether we recognize it or not at the time.

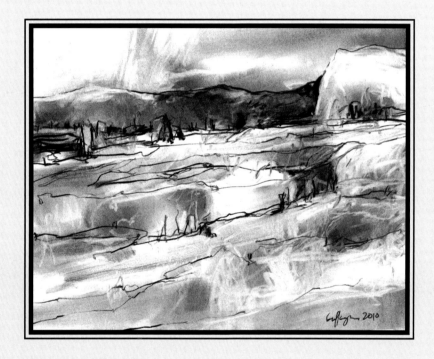

* * *

On the Backside of the Desert

Lord, like Moses, we're in hiding
Near Mount Horeb, we are found,
On the backside of this desert
We encounter holy ground.

Slow of speech and so resistant,
So like Moses, fallen man . . .
On the backside of this desert,
Sinners in a foreign land.

Running there from truth and justice
With no place at all to hide,
On the backside of this desert,
Man and deity collide.

Lord, we quarrel with your calling,
Yes, we argue and retreat;
On the backside of this desert,
Help us feel the searing heat.

Kill the prideful rebel in us,
Burn him out through drought and pain,
On the backside of this desert,
Show us, Lord, who truly reigns!

Take us to our burning bush, Lord,
Yes, confront us with our sin,
On the backside of this desert,
May our search for truth begin.

Help us hear the true Word spoken
From that bright Shekinah Flame . . .
On the backside of this desert,
Teach us your eternal name.

Teach us there what finally matters,
In the end, Lord, have your way . . .
On the backside of this desert,
Teach us, Lord, how not to stray.

QUARANTINE

He . . . guided them in the wilderness.

—Psalm 78:52

* * *

Then Jesus was led by the Spirit into the desert to be tempted.

—Matthew 4:1

* * *

The wilderness is a place where growth comes hard, water is scarce, and you plod on when there's no end in sight. . . . God's Word is . . . your wilderness-survival guide. After using it Jesus left the wilderness clothed in the power of God's Spirit, ready to launch his ministry.

—Bob Gass

* * *

The word *quarantine* comes from the Italian word *quarantena*. It means "forty days." The word was coined in Venice in the fourteenth century during an outbreak of the Black Death (bubonic plague). It describes the length of time that those who had been exposed to the disease would be set apart. For forty days, the exposed population would be watched and tested. The quarantine was, in essence, a time of *probation*—a designated life-or-death, make-or-break evaluation period. If, after the designated forty days, they were found to be disease-free, the quarantined were released.

In the Bible, the number 40 is mentioned almost 150 times. More often than not, the number 40 signifies trial, waiting, and testing. Jesus was tested and tempted by the devil for forty days in the desert. Moses was on Mount Sinai/Mount Horeb for forty days without food or water. The Israelites wandered for forty years (i.e., one generation) in the desert. In the scriptures, the number 40 signifies a time of refining and learning to hear God's voice. It speaks about the wilderness experience—it is the language of adversity, the language of the desert.

The number 40 not only indicates a probationary period but also a time of *potential* illumination and maturation of faith, a sanctifying process.

* * *

After his bodily resurrection, Jesus appeared to his disciples and taught them for forty days. The forty days of post-Resurrection ministry must have surely been a humbling time of wide-eyed awe for his followers as they began to learn the *true* nature and identity of this Anointed One, this one named Jesus (Savior) whom they had seen and heard and listened to, whom they had examined and their hands had touched (1 John 1:1) for three miracle-filled years. I'm sure this divinely initiated forty days of post-Resurrection ministry was a faith-refining, faith-defining, and deeply moving period for those who had been called and set apart for this illuminating purpose. Jesus "opened their minds" during that forty-day period. He helped them to understand that by faith they were declared "plagueless" and that his atoning death on the cross of Calvary had made it so. For forty days, He opened their minds so that they could truly understand the prophetic scriptures.

After those forty days, the risen Lord left them. But before leaving, He told his followers to isolate themselves for ten more days in Jerusalem. He told them to wait there together and to pray. The disciples trusted Him, and they obeyed. They *believed* God's Word and acted upon it.

On the fiftieth day after the Resurrection, at the prophetically designated time of Pentecost (see Leviticus 23:15–16), the Church exploded to life when, just as promised, the Living Water of the Spirit of God was poured out upon them just as the prophet Joel had foretold (see Joel 2:28–29). Then and there, the scattered seed from the Father (through the Son and Holy Spirit) came to life and the Church was born. Then and there, the disciples were equipped to fulfill the last command that Jesus had given them:

> All authority in heaven and on earth has been given to me. Therefore go and make disciples of all nations, baptizing them in the name of the Father and the Son and of the Holy Spirit, and teaching them to obey everything I have commanded you.

And surely I am with you always, to the very end of the age. (Matthew 28:18–20)

Then and there, the Church began to stir. Then and there, the Great Commission was initiated, and the rest is history. The Church, the Bride of Christ, has born her fruit.

* * *

It seems that the world—indeed, *all* of creation—has been subject to divine "quarantine" because of sin:

> For the creation was subjected to frustration, not by its own choice, but by the will of the one who subjected it, in hope that the creation itself will be liberated from its bondage to decay and brought into the glorious freedom of the children of God. (Romans 8:20–21)

The Bible teaches that for a time, we live in the "back forty wilderness" of a fallen world. The Church, the Bride of Christ, is not exempt from the world's troubles. Believers and nonbelievers alike are living, for a time, here in quarantine mercifully isolated from that which is eternally righteous, just, and good….the immutable consuming fire of God's holiness.

> We know that the whole creation has been groaning as in the pains of childbirth right up to the present time. Not only so, but we ourselves, who have the first fruits of the Spirit, groan inwardly as we wait eagerly for our adoption as sons, the redemption of our bodies. (Romans 8:22–23)

* * *

Quarantine

In this wilderness of living,
Test us, Lord, and help us learn,
Teach us, Father, here to trust You,
And the Truth here to discern.

Help us see You in the desert,
Forty days and forty nights . . .
Then give thanks that You were able
To resist temptation's blight.

Great Physician, show us clearly
While we're here in quarantine,
Why we need this just probation ,
And a sinless Go-Between.

May, some day, we learn to thank You,
For the dry and barren ground…
Where your Spirit came to woo us,
And where we, the lost, were found.

Give us Grace to find redemption
At the Cross, Lord, where You died;
Fill these cups to overflowing,
Yes, to be your fruitful bride.

WILDERNESS OF SIN

In most western cultures where sheep are raised, the normal way to get the flock from point A to point B is by driving them from behind using highly trained dogs. By contrast, in the cultures of the Middle East, the shepherd *walks ahead* of the flock. The sheep know and trust the shepherd's voice. The good shepherd goes *before* the flock, and the sheep *follow* him through often rugged terrain until they reach green pasture and water.

In the book of Exodus, we are told how the entire nation of Israel was led out of Egypt where they had been enslaved for four hundred years. We are told that the Israelites were led out of bondage by the presence of God whose glory appeared to them in a *pillar of cloud* (see Exodus 13:21–22). The people were *shepherded* through the desert wilderness this way for forty years until they reached the waters of the Jordan River and the *pasture* of the Promised Land.

The forty-year wilderness experience was not easy. In Exodus chapter 17, we are told how the disgruntled Israelites rebelled against Moses. They were tired. They were discouraged and hopeless. They were, in fact, so distraught that they actually wanted to return to Egyptian bondage rather than continue to wander through the desert. And in a region identified as the Desert of Sin (in Hebrew, *tsin* means "crag-like" and "thorny"), their anger and frustration boiled over. The thirsty, discouraged, and embittered flock rebelled against Moses and their liberating Shepherd….God.

Scripture tells us that there, in the Desert of Sin, at a spot called Meribah (a Hebrew word meaning *provocation and quarreling*), the Lord provided for the parched and despairing Israelites when He caused water to flow miraculously from a rock.

This episode of Jewish history was recalled centuries later when the Psalmist wrote,

He says, "I removed the burden from their shoulders; their hands were set free from the basket.

In your distress you called and I rescued you, I answered you out of a thundercloud; I tested you at the waters of Meribah." (Psalm 81:6–7)

* * *

Now Does Meribah Consume Us?

Are we driven by emotion
And the scars of yesterday?
Do the dried-up streams behind us
Still impede and damn our way?

Do we grumble at our Shepherd
In the wilderness of sin?
And does Meribah consume us
With the things that "should have been?"

Do we dwell in unforgiveness?
Are we haunted by the past?
Are we lost in crags of mem'ries
And the shadows that they cast?

Or is there *Another* calling . . .
A *proposal* heard ahead:
"Follow me," the Shepherd whispers.
"Don't remain among the dead."

Do we long for that tomorrow
When we'll see the Bridegroom's face?
Have we answered His proposal
And experienced His grace?

Turn around!...Tomorrow beckons.
He proposes—we decide.
Will we die here in the desert
Or believe Him as His bride?

Turn around! Embrace the future!
Leave the hopeless past behind.
Hear the promise of the Shepherd....
Listen..... *"Seek and you will find."*

Leave behind the desolation . . .
Know the hope *tomorrow* brings!
Turn around!.... Behold the mountain
Where the Living Water springs!

* * *

The absence of future hope has an amazing capacity to reach into the present and eat away at the structure of life, as termites would a giant foundation. Hope is that indispensable element that makes the present so important.

—Ravi Zacharias

We have this hope as an anchor for the soul, firm and secure. It enters the inner sanctuary behind the curtain where Jesus who went before us, has entered on our behalf. He has become a high priest forever, in the order of Melchizedek.

—Hebrews 6:19–20

DESERT TEACHER

But rejoice that you participate in the sufferings of Christ, that you may be overjoyed when his glory is revealed.

—1 Peter 4:13

* * *

The God of Abraham, Isaac, and Jacob, the God who has revealed himself in the Bible through the prophets, the apostles, and through his Son, Jesus Christ, does not always prevent us from wandering, even staggering, through the scorching discomfort of wilderness heat. He doesn't promise to keep us from error, pain, or suffering. He doesn't promise to shelter his children from trouble, trial, and difficulty in this world. In fact, He allows his children to experience, sometimes, excruciating heartache. He does so in order to instruct and train, to purify, to set apart, and to refine. He will do so for our own ultimate good and for the ultimate good of those around us… our loved ones, friends, neighbors, and perhaps, even our enemies.

Like the wandering Israelites in the desert, we may surely doubt, murmur, and complain. We may cry out in anguish at times. God knows that learning the hard way—learning to trust and to obey Him—is often the more needful and excellent way, the *only* way to grow into the likeness of Christ.

The desert is a teacher. And God will use it in our lives for our benefit and for His glory.

God does this, we are told, in order to perfect our faith (see Hebrews 12: 2). God is the Master Vinedresser, after all, and those who have been grafted in to his Vine can expect his skillful, though sometimes very painful, pruning. We may not understand the pain when the pruning shears are suddenly cutting into our lives or unexpectedly lopping off cherished dreams and expectations. But if we know that He is with us always, and if we *truly know* in our hearts that He alone is immutable and sovereign and good and that He is in control of our sanctification and growth, we may persevere and be comforted during the process.

* * *

Affliction comes to us, not to make us sad but sober, not to make us sorry but wise.

—Henry Ward Beecher

* * *

May the Desert Be Our Teacher

Lord, the desert has a purpose
Though the climb may seem too steep . . .
Help us trust your Word and Reason
When the darkness is too deep.

Teach us wisdom when we stagger,
Help us grow, Lord, when we fall.
Make us fruitful by this pruning,
Stronger when we hit the wall

When the pain's excruciating
And our strength may melt away,
May the desert be our teacher,
Through the wasteland, show the way.

Lead us, Shepherd, through the darkness,
Give us ears to hear your voice . . .
May your rod and staff bring comfort
And the grace, Lord, to rejoice.

May the desert be our teacher,
Through the wasteland, show The Way.
Please, Lord, cling to us more dearly,
May the nighttime turn to day.

* * *

If you are going to be used by God, He will take you through a number of experiences that are not meant for you personally at all. They are designed to make you useful in his hands, and to enable you to understand what takes place in the lives of others.

—Oswald Chambers

HIGH PLACES THAT DECEIVE

Scripture refers to the wilderness quite often, and when it does, it usually means a barren, dry, and quite inhospitable region. The Bible also tells us about a peaceful Promised Land, a land "flowing with milk and honey." These references do not *only* indicate actual geographic locations in and around the Holy Land of Israel, they also describe the *subjective realm* of the human spirit...an *inner terrain* of consciousness and conscience, regions of the human heart and soul.

All of us must travel through the ups and downs of this inner region. We all have embarked on a pilgrimage of the heart, and as such, each individual must journey through his or her own "spiritual landscape."

We wander. We wonder. We seek. We stumble and stagger, and sometimes, we fall. But then we get up and move forward again toward a goal—an eternal "promised land" that we sense lies ahead (see Ecclesiastes 3:11). Along the way, we discover springs and oases, places of refreshment. These are places of refuge, comfort, and encouragement. These are the welcome places that beckon to the spirit:

"This is the right way. You're on the right path. Rest here for a while before moving on."

But there are just as many crooked paths, dead-end gulches, and bone-dry ravines, perplexing places that frustrate, disappoint, damage, and deeply discourage us. These, of course, are the "wilderness"—rough places in a fallen world that often threaten to undo and derail us.

Biblical "High Places"

And in this regard, the Bible *also* teaches that there are certain *high places* in this land... this "inner terrain." In Scripture, we are told about two *types* of high places. On the one hand, we learn about the enticing high places where false gods, false promises, and idols of all shapes and sizes are promoted and vie for our attention, affection, and worship. (In scripture, these are the high places dedicated to such false gods and goddesses as Molech, Topheth, Asherah, Chemosh, Baal, and more. Today, of course, they have different names.)

On the other hand, the scriptures also tell us about a *different* type of high place. These are the high places where God has chosen to reveal his eternal attributes and his purposes and plans to mankind. In both the Old and New Testaments, these high places have names like Mount Sinai (Mount Horeb), Mount Nebo, Mount Carmel, Mount Tabor (the Mount of Transfiguration), Mount Moriah (Zion), and more.

As we make our way through our personal "inner terrain"....(this "valley of the shadow of death" as the psalmist put it)...we are advised and invited to look up and to take careful note of the different "high places" that call out to us along the way.

Lord, teach us to discern and to distinguish between the "voices" of both *types* of high places in our lives. Help us to choose our path wisely. Help us to hear the *true* Good Shepherd's voice. Help us to choose your Way (see John 14:6).

* * *

Now one of Saul's servants was there that day. . . . He was Doeg the Edomite, Saul's head shepherd.

—1 Samuel 21:7

If you are familiar at all with the Old Testament record of King Saul, you may recall that his career was one that *began* with blessing and promise. As his life and reign unfolded, however, he fell into persistent patterns of prideful disobedience before God. As a consequence, his emotional and spiritual state unraveled. King Saul was increasingly plagued with spiritual and emotional *dis*-ease until paranoia overwhelmed him... eventually to the point of death.

According to 1 Samuel 21:7, King Saul's head shepherd was a man named Doeg. In Hebrew, the word *doeg* means *to worry, to be anxious, doubtful, and fearful.* Perhaps, there is a lesson here. When we persistently turn a deaf ear to the voice and call of the true Good Shepherd, we will inevitably fall prey to the destructive "high places" of wilderness idolatries.

* * *

High Places that Deceive

Now, if Doeg's your head shepherd,
Rest assured, you'll find no peace.
"No Shalom" will be your pasture,
And confusion will not cease.

His anxieties will lead you
To "high places" that deceive....
And where idols tempt... then taunt you,
And where sin and ill's conceived.

It's where Mammon may consume you...
And indulgences are sold.
It's where Asherah seduces,
It's where Baal collects his toll.

It's where grace and rest elude you;
It's where *busy*-ness prevails . . .
Where the din of rebel chatter
Is a cliff you cannot scale.

It's a pit that has no bottom . . .
It's a night that has no dawn.
It's a never-ending treadmill . . .
It goes on...and on... and on . . .

* * *

But there is *another* Shepherd...
One who's good and kind and true;
And a high place in his presence
He's preparing now for you!

Yes, his voice is calm and gentle
Like a brook that gently falls . . .
Living water for the dying,
Like a soothing harp...He calls.

This Good Shepherd knows high pastures
Where the skies are clear and rare,
And His springs provide still water . . .
If you ask....He'll take you there.

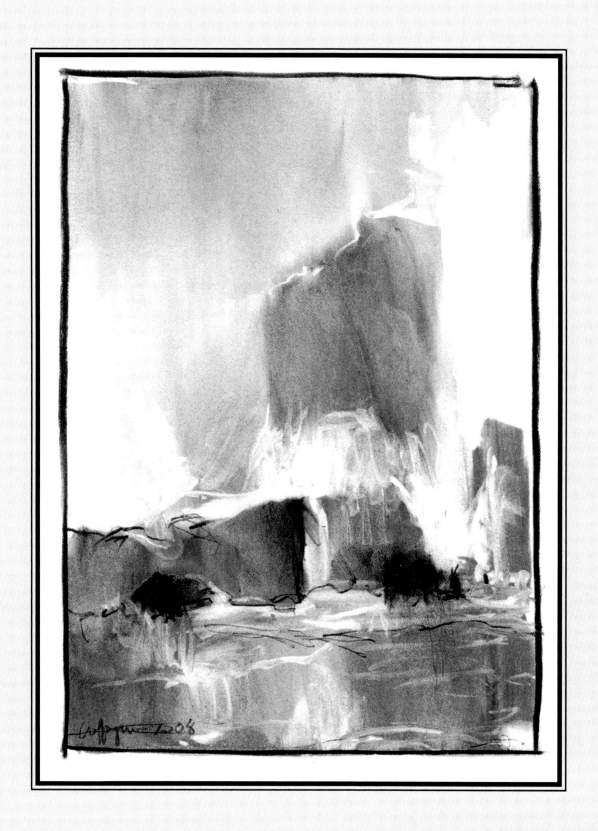

PART TWO

FROM WILDERNESS TO WATER

[We may know God] . . . by the creation, preservation, and government of the universe . . . before our eyes like a beautiful book in which all creatures, great and small, are as letters to make us ponder the invisible things of God: his eternal power and his divinity.

—*Belgic Confession, 1516*

* * *

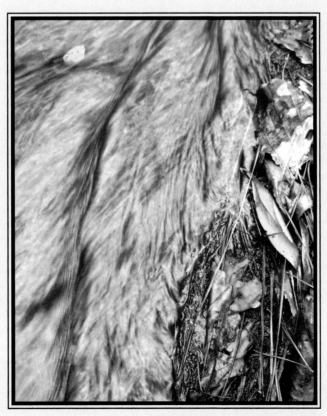

This Guilded Tome

God in heaven, speaking volumes
Through creation's guilded tome,
Themes and verses streaming by us,
Each designed to guide us home.

May we pause, Lord, by these waters,
Prompt the soul as time flows by . . .
Father, help us find refreshing
When our hope is running dry.

What we need to know before us
In the desert…by the springs,
Helping every honest seeker
Find the Truth creation sings!

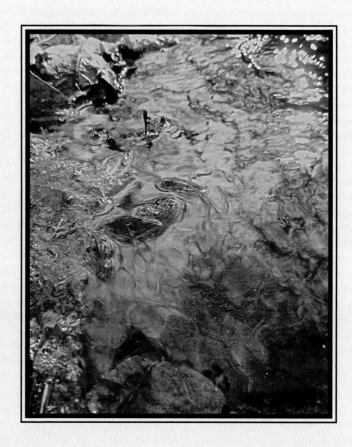

THE WATER

In the beginning God created the heavens and the earth. Now the earth was formless and empty, darkness was over the surface of the deep, and the Spirit of God was hovering over the waters.

—Genesis 1:1–2

* * *

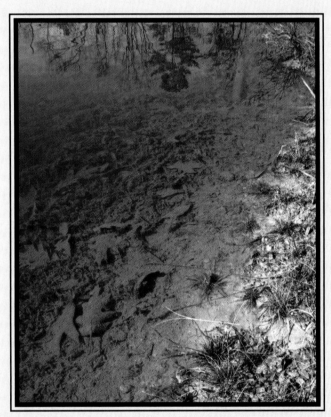

The Bible literally begins and ends with references to water (see Genesis 1 and Revelation 22). Water courses through practically every book of the Bible—Old Testament and New. Water flows through the Bible narrative just as surely as the narrative flows through historical space and time.

Water is showcased throughout Scripture like a prominent actor in a play. The rains come, and the rains are withheld. Floodwaters rise and fall, seas and rivers part, water turns to blood, and water turns to wine. Water flows through unspoiled Paradise, and it flows from the barren desert rock. Moses is plucked from the waters of the Nile as a baby. Jonah and Peter and Paul are saved out of the sea. The Samaritan woman encounters Jesus at a well. Jesus emerges from the waters of the Jordan River, equipped and empowered to perform miracles and to preach, to teach, and to disciple. And on and on it goes.

The Bible not only enlists and incorporates the *fact* of water into the divine narrative time and time again but also seems to insist upon the presence of the *idea* of water at a deeper level. Water is purposefully and vitally at play in God's Word and seems to be somehow intrinsically related to God's redemptive plan and program for this broken world.

The earth is the Lord's, and everything in it, the world and all who live in it; for he founded it upon the seas and established it upon the waters. (Psalm 24:1-2)

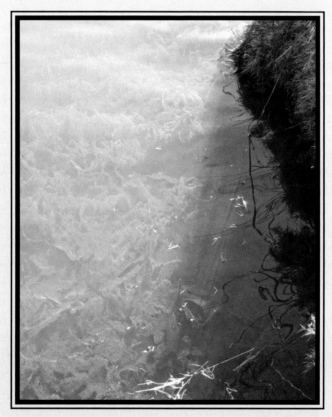

Water pulls us close and draws us in. Water is more than just a thirst-quenching liquid that keeps our bodies going. There is something more here....an emotional and spiritual *draw* of seminal importance. Water suggests something wondrous and profound. We all seem to have a divinely seeded, subconscious desire to immerse and bathe ourselves in it.

Water is relentlessly and powerfully *attract*-ive.

When we stand before the magnificent expanse of the ocean, when we hear the ceaseless and mesmerizing rhythm of the surf, when we listen to the powerful and sublime constancy of the voice of a waterfall or the soothing sound of a babbling brook or garden fountain, we are often drawn profoundly to a place of peace and comfort, a transcendent place of wonder.

One might imagine that water is in some way a divinely appointed servant, a "prophet" of sorts, commissioned to deliver a vital and universal message to the heart and soul of all mankind, a message that is simple, straightforward, direct, and, paradoxically at the same time, elusive and transcendent. Its message is something that the smallest child may innocently delight in while philosophers may forever ponder its fathomless depths.

Water as a material element seems to have been *designed* to help carry us… emotionally and spiritually… to the shores of Truth and, ultimately, to the merciful, redeeming love of God's holy and eternal presence.

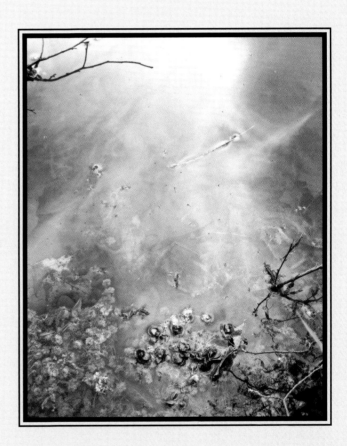

* * *

Then the angel showed me the river of the water of life, as clear as crystal, flowing from the throne of God and the Lamb.

—Revelation 22:1

BESIDE STILL WATERS

The Lord is my shepherd, I shall not be in want.
He makes me lie down in green pastures:
He leads me beside still waters.
He restores my soul.

—Psalm 23:1-3

* * *

The book of nature is a fine and large tapestry rolled up, which we are not able to see all at once, but must be content to wait for the discovery of its beauty and symmetry, little by little, as it gradually comes to be more and more unfolded and displayed.

—Robert Boyle, 1691

* * *

What is it, I wonder, about quiet, still water that intrigues us so? Why do "still waters" seem to invite contemplation and reflection? Why, I wonder, do still waters seem to bring us peace?

I am told that a good shepherd will lead his flock to quiet waters so that his sheep may drink and be restored. Indeed, it is my understanding that sheep will not drink from flowing or agitated water at all…even if they are dying of thirst.

Recently, as I stood at the edge of a West Georgia pond and looked into the placid water there, it dawned on me that I was seeing three conjoined but somehow separate dimensions, a mysterious visual trinity. Here was a visual feast of interwoven textures, light and shadow, rhythm, color, and interlocking spatial realities all wrapped up in the overriding context of *still, quiet water.*

There was, of course, before me the *surface* of the water upon which leaves and branches floated and where the shoreline touched. I was struck by the immediacy of those things at the surface. They were, quite simply, here and now…a *Present* tangible reality.

But then my eye was drawn *beneath* the surface of the water, and it occurred to me that here were things that had, over time, sunk into the *Past*, things now somewhat vague and unclear, things pressed down and muddied by time. Here were submerged memories (some good, some bad), real things for sure, but somehow things gone by, things covered up, and things nearly forgotten.

And then I became aware of another…a third dimension. As I gazed down at the water, I realized that I could also see blue sky, clouds, treetops, and sunlight, things above and beyond the surface. These, of course, were just reflections, but certainly they were as real as the "here and now" things on the surface and also just as *real* as those *past things* submerged below. There at the water's edge, the eternal and spiritual seemed to *invade* what

44

was mundane, time-locked, and tangible. The reflections of those things above seemed to suggest an unrealized *Future* promise. They seemed to offer hope.

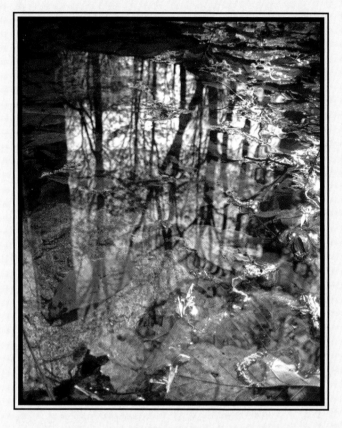

* * *

I wonder . . . is it possible that when we find ourselves beside still waters, are we being invited there to *slow down*, to *drink in*, and be restored? Is it possible, perhaps, that we are being asked there to consider and enjoy the glory and presence of a God who has skillfully woven this garment of creation into being? Is it possible that we are being invited there to listen with our eyes and to understand with our hearts as we reflect?

And then, I wonder…how and why it is that we, mere creatures ourselves, are even *able* to apprehend and to appreciate the cascading beauty of nature, this sublime and magnificently woven, light-filled "coat of many colors" so elegantly designed and intertwined with the triune threads of space and time and matter.

* * *

Praise the Lord, O my soul.
You are clothed with splendor and majesty.
He wraps himself in light as with a garment . . .
And lays the beams of his upper chambers
on their waters.

—Psalm 104:1-3

Reflections on Reflections

On this shore, Lord, help us ponder
These Tri-Unities we see.
May a seed there be implanted…
Help us glimpse eternity!

Help us drink in these reflections
And enjoy your play of Light,
Baptize us with Living Water,
So your dawn may chase our night.

And if unforgiveness festers
In the wounds of yesterday,
Sin submerged beneath the surface,
Please, Lord, banish them, we pray.

Please immerse us in creation,
By these waters help us know…
And then if a seed be sown there,
Holy Spirit, make it grow!

Teach us truth on banks of glory;
Help us fathom what is past…
Draw us, Father, to your presence
In the net the Son has cast.

Help us hear your higher calling
Even as we gaze below,
And then bless our understanding,
So your love, Lord, we may know.

Help us see You in creation…
Lord, there's more than meets the eye;
Help us grasp your very nature,
Help us wonder "how" and "why."

Help us move beyond the surface
Of this broken world we're in…
Teach us, Lord, of sweet redemption
So we may be born again.

In this garment of creation,
Revelation!… Sea of Glass!
Help us know the Blessed Hope, Lord…
Distant Shore…our home at last!

✳ ✳ ✳

What are the heavens, the earth and the sea, but a sheet of royal paper, written all over with the wisdom and power of God.—Thomas Brooks

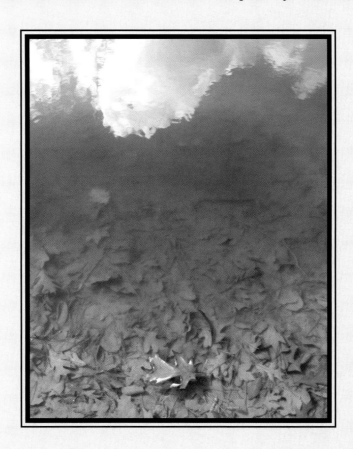

TIDAL POOL

Although God is invisible and incomprehensible, God wills to be known under the form of created and visible things, by donning the garment of creation.

—Alister McGrath

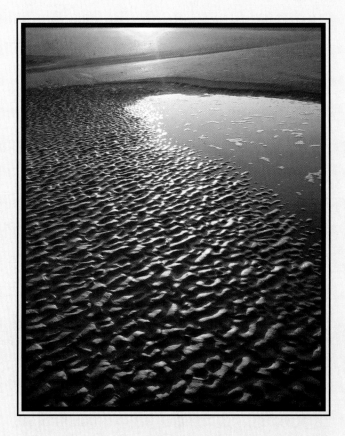

* * *

On a vacation trip with my family a few years ago to the South Carolina shore, I walked the beach at dawn. Every morning, the tide was out, and every morning, there was a tidal pool left behind in the sand. I was struck by the elegance and beauty in and around those pools. As the sun rose over the ocean and as the daylight broke across the beach, I was enthralled by the graceful harmonies that were revealed in and around those tidal shallows. I was arrested by the alluring and intrinsic beauty of God's natural creation. The rhythmic patterns left in the sand seemed to showcase evidence of a symphony, a delicate score orchestrated on the shoreline and performed during the night. To me, the light of dawn revealed that a sand-etched, romantic nocturne had taken place just hours before.

* * *

There is a beautiful book in the Old Testament called the Song of Songs. It is a poetic allegory that reminds the reader that God is a divine lover who often beckons to his beloved simply by his quiet presence. The Song of Songs is a reminder that God romances the soul of man through the beauty and wonder of his intricately woven garment of creation....

> Look! There he stands behind our wall, gazing through the windows, peering through the lattice. My lover spoke and said to me, "Arise my darling, my beautiful one, and come with me." (Song of Songs 2:9–10)

* * *

May This Tidal Pool Remind Me

On this beachhead we have landed,
On these shifting sands we roam....
Help us find the true foundation,
By your Word, Lord, lead us home.

May this tidal pool remind me
Of your beauty and your grace;
Did You draw me here to worship?
Did You guide me to this place?

Did You offer here reflection
Of the blessed hope to be?
Did You place this pool before me
To suggest eternity?

Is this pool a short epistle
From the Morning Star of dawn?
Does it point to coming glory
That goes on and on and on?

May I find here truth in person?
A creative, awesome mind?
An immutable foundation
Who exists outside of time?

Dear Lord, if you truly love us,
Then how might You tell us so?
Might You speak through nature's beauty
In a shoreline tidal flow?

Teach the heart, Lord, of the matter...
Help us hear your Song of Songs!
Through the harmony and rhythm,
Call the bride for whom You long.

May we sense your soft proposal
In the sand your tides caress.
Give us grace to say, "I do, Lord!"
Give us grace, Lord, to confess.

In these tidal deed reflections,
May You teach us to adore...
Help us know the Light of Glory,
Draw us to your distant shore.

* * *

Your proposal, Lord, was tendered…
From the cross…a marriage vow!
See your spotless bride approaching…
There! At Calvary we bow.

* * *

Let us rejoice and be glad and give Him glory!
For the wedding of the Lamb has come,
and his bride has made herself ready.

—Revelation 19:7

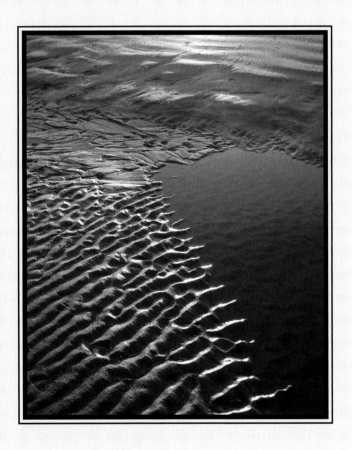

POURED OUT

Jesus spoke to them in parables, saying: "The kingdom of heaven is like a king who prepared a wedding banquet for his son."

—Matthew 22:1–2

* * *

The Spirit and the bride say, "Come!" And let him who hears say "Come!" Whoever is thirsty, let him come; and whoever wishes let him take the free gift of the water of life.

—Revelation 22:17

* * *

If the Bible is true, as I believe it is, then God, the uncaused cause of the universe, the creator of all space and time and matter, must have designed and created the elements for his own divine purpose and for his own glory. In light of that, it seems to me that *water in particular* holds a unique spiritual message for the human *heart*.

In the Bible, Jesus, the incarnate Son of God, set the stage for this divine romance when He performed his first recorded miracle in the town of Cana on the northern shore of the Sea of Galilee. It was there that He turned water into the finest of wedding wines (John 2:1–11). His doing so was no accident.

Christ came to earth to seek his bride, and there at Cana, at the very beginning of His public ministry, He began the wooing process by using water to impress his beloved and to draw her near. Three years later, at the very end of his ministry in the upper room in Jerusalem, Jesus offered his disciples a "wedding wine" proposal toast of a different sort.

Then he took the cup, gave thanks and offered it to them, saying, "Drink from it all of you. This is my blood of the covenant, which is poured out for many for the forgiveness of sins." (Matthew 26:27–28)

* * *

Water is a symbol and a sign in the scriptures. Water is a picture or a *type* of the Holy Spirit, the Spirit of Truth. Water is an earthly *shadow* of the Spirit of God, the third Person of the Divine Trinity and the empowering wellspring of Life itself.

I will pour water on the thirsty land, and streams on the dry ground; I will pour out my spirit on your offspring, and my blessing on your descendants. (Isaiah 44:3)

I am persuaded that God's message…his *proposal…* is somehow hidden in the element of water. I am also persuaded that those who truly thirst will truly seek and those who truly seek will find the waiting Bridegroom.

* * *

Golden Goblet for the Bride

May the cup of Cana beckon…
May the wedding feast begin!
May the purifying water
Now remove the stain of sin.

Help us taste the wedding water...
Help us taste the wedding *wine*!
May we sense the glory 'round us...
May we sense true grace divine.

Perfect passion of the Bridegroom,
Perfect love, Christ crucified….
There poured out for his beloved,
Golden goblet for his bride.

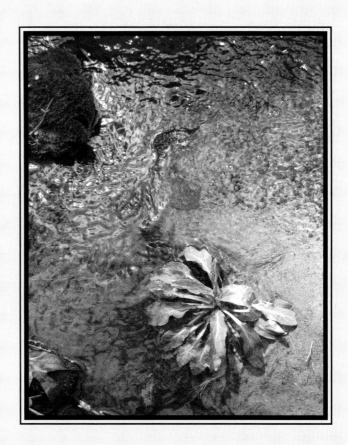

LIVING WATER FROM THE WELL

With joy you will draw water from the wells of salvation.

—Isaiah 12:3

* * *

In the first verse of Isaiah 55, in the Old Testament, we read this divine invitation, "Come all you who are thirsty, come to the waters." This invitation delivered through the prophet Isaiah is couched in terms of a covenant vow:

> Listen, listen to me, and eat what is good, and your soul will delight in the richest of fare. Give ear and come to me; hear me, that your soul may live. I will make an everlasting covenant with you, my faithful love promised to David. (Isaiah 55:2–3)

In the New Testament, when Christ met the Samaritan woman at the well in the town of Sychar (see John 4:4–26), we are told that Jesus knew everything about her. He knew her past, and He knew her struggles, her wounds, her heartaches, and her pain. He knew her sins. He also knew that the water from that particular man-made well could only satisfy her *physical* thirst…and that just temporarily.

Just as He told the woman at the well, Jesus tells us today that if we truly have *thirsty* hearts and ears to hear and if we would but ask, He would provide "Living Water,"

the kind of water that restores the soul, revives the spirit, and satisfies abundantly for all eternity. Indeed, Jesus tells his followers that He not only can *provide* this Living Water, He claims that He IS the Living Water (John 7:37–39).

* * *

For two years, I took photographs on the water's edge, the shores and banks of lakes and ponds and streams near my home in Georgia. Perhaps, I was pulled there beside those "still waters" for a purpose—for instruction, correction, and restoration. Like the desperately needy woman at the well, I discovered that Jesus, God's perfect sacrifice poured out for us, promises to change everyday water into Living Water in the same way that He changed water into wine at the wedding feast of Cana.

In so doing, Jesus issues a *faith invitation* to us. It is an invitation to a future, eternal wedding feast, a joyful banquet of such delight that we can scarcely begin to imagine it.

* * *

Draw Us to the Well of Glory

Give us, Lord, the Living Water,
 Like the woman at the well…
Help us taste the wine of Cana,
 Lord, cast out each living hell.

Draw us to the well of glory…
 Give us grace to see the light.
Help us now to trust your promise
 When surrounded by the night.

If a bitter past still haunts us…
 Help us cast it all aside.
Heaven, help us change our focus,
 And in You, Lord, to abide.

May each pain beneath the surface,
 Lord, flow through the way of grace.
May we fathom your sweet mercies.…
 And above all, seek your face.

May we taste the wine of glory
 At the water's edge, we pray …
Help us see beyond the surface
 Into your eternal day.

IN THE SHADOW OF CHERITH

Let us draw near to God with a sincere heart in full assurance of faith, having our hearts sprinkled to cleanse us from a guilty conscience and having our bodies washed with pure water. Let us hold unswervingly to the hope we profess, for he who promised is faithful.

—Hebrews 10:22–23

* * *

In the Old Testament, we are told of the prophet Elijah fleeing from King Ahab and his wife, Jezebel. Elijah was fleeing for his very life. He was fleeing from the wickedness of his day, the governing powers who sought to silence God's message of warning that the prophet had been proclaiming.

We read,

And the word of the LORD came to him [i.e., Elijah], saying, "Go away from here and turn eastward, and hide yourself by the brook Cherith, which is east of the Jordan. And it shall be that you shall drink of the brook, and I have commanded the ravens to provide for you there."

So he went and did according to the LORD, for he went and lived by the brook Cherith . . . And the ravens brought him bread and meat in the morning and bread and meat in the evening, and he would drink from the brook. (1 Kings 17:2–6)

* * *

God directed Elijah to a place of refuge, a place called Brook Cherith (*pronounced* ke-*REETH*). There God provided Elijah a place to hide from the idolatrous enemy who stalked and threatened to kill him. There Elijah was given respite and was miraculously fed. There at Brook Cherith, he was delivered from danger and evil, and there he was comforted, restored, and sustained.

Elijah was saved by the waters of Brook Cherith—a stream in the desert.

* * *

You are my hiding place;
you will protect me from trouble
and surround me with songs of
deliverance.

—Psalm 32:7

* * *

The Hebrew word *cherith* is most intriguing. The word literally means *a cut*, but the *primary* word from which *cherith* is derived is more specific and more telling; the *root* word means literally "to cut a covenant."

In the ancient world, when two parties entered into a binding agreement, when men made a promise to one another that they sincerely intended to keep, they would often seal their covenant oath in blood. They would do so by killing an animal—a bull, a goat, a sheep... or perhaps, a lamb. The body of the dead animal would then be cut in half and the two halves would be placed side by side on the ground. Both parties would then walk through the severed and bloodied parts of the covenant sacrifice. They would both pass through the blood. In effect, by doing so, they were symbolically saying to one another, "If I should break my word to you in this matter, may this be done to me!"

A *sacrifice* was offered. A covenant was *cut*. Blood was spilled, and a *promise* was sealed.

* * *

Cut of Promise, Wound of Grace

Lord, Cherith....our place of hiding,
May your presence there be known....
Son of God's foreshadowed story,
Come to earth and sins atoned.

Brook Cherith, your saving waters
Are today in Christ fulfilled.
Now this cup is overflowing...
Idol threats have now been stilled.

Shelter in our time of trouble,
Brook Cherith, sweet hiding place!
There we enter, Lord, your presence...
Cut of promise...wound of grace.

There! The Promised One...Messiah!
In the shadow of Cherith....
There! Reflected revelation,
Quenching fires of unbelief!

This, your covenant of promise...
Bread and Water...blood to wine;
May this fountain cleanse the sinners
Who are grafted in the Vine.

Brook Cherith, your waters tell us
Of a truth still yet to come.....
Pointing to the Hope of Glory,
Bridegroom, King,....Anointed One!

* * *

Then he took the cup gave thanks and offered it to them, saying, "Drink from it all of you. This is my blood of the covenant, which is poured out for many for the forgiveness of sins. I tell you, I will not drink of this fruit of the vine from now on until that day when I drink it anew with you in my Father's kingdom."

—Matthew 26:27–29

* * *

There is a fountain filled with blood
Drawn from Emanuel's veins;
And sinners plunged beneath that flood
Lose all their guilty stains . . .
E'er since, by faith, I saw the stream
Thy flowing wounds supply,
Redeeming love has been my theme . . .
And shall be till I die.

—William Cowper, 1731–1800

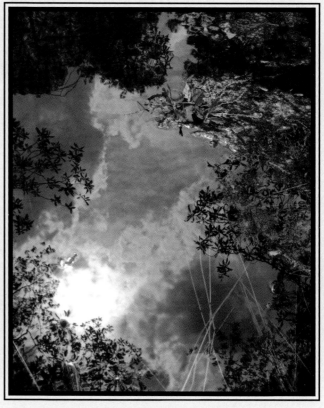

SECOND ADAM ON THE SHORELINE

As soon as Jesus was baptized, he went up out of the water. At that moment heaven was opened, and he saw the Spirit of God descending like a dove and lighting on him. And a voice from heaven said, "This is my Son, whom I love; with him I am well pleased."

—Matthew 3:16–17

* * *

By the waters of the Jordan,
They saw heaven open wide;
They saw Jesus for the first time
As He came to seek his bride.

At the water, they all witnessed
Holy God's self-sacrifice,
Ransom paid for desert-dwellers,
Those who could not pay the price.

At the Jordan, they encountered
Servant God and Son of Man,
Second Adam on the shoreline,
Living Water, spotless Lamb.

There at those baptismal waters,
Christ anointed from above,
Christ empowered by the Spirit,
Pouring out the Father's love.

* * *

Father, help us see more clearly,
Help us find You on the shore.
Help us trust this One appointed…
Give us faith…then give us more.

Father, help us see this Jesus
By the water You provide…
Help us bow in adoration,
Help us see him crucified.

Help us see the Resurrection,
At the water's edge today…
And then fill us, Holy Spirit,
Pour into these jars of clay.

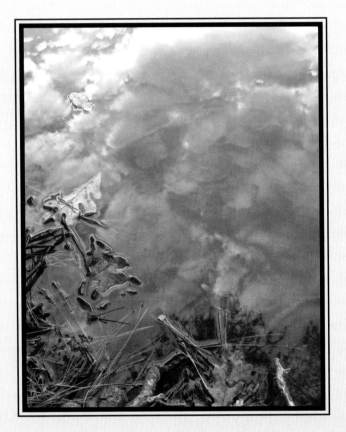

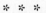

For I will take you out of the nations; I will gather you from all the countries and bring you back into your own land. I will sprinkle clean water on you, and you will be clean; I will cleanse you from all your impurities and from all your idols. I will give you a new heart and put a new spirit in you; I will remove from you your heart of stone and give you a heart of flesh. And I will put my Spirit in you and move you to follow my decrees and be careful to keep my laws.

—Ezekiel 36:24–27

* * *

But when the kindness and love of God our Savior appeared, he saved us, not because of righteous things we had done, but because of his mercy. He saved us through the washing of rebirth and renewal by the Holy Spirit, whom he poured out on us generously through Jesus Christ our Savior, so that, having been justified by his grace, we might become heirs having the hope of eternal life.

—Titus 3:4–7, NIV

LIVING WATER, HAVE YOUR SAY

I am poured out like water . . . they have pierced my hands and my feet.

<div align="right">

—Psalm 22:14–17

</div>

<div align="center">

* * *

</div>

The creation is a visible disclosure of the invisible God, an intelligible disclosure of the otherwise unknown God. Just as artists reveal themselves in what they draw, paint and sculpt, so the Divine Artist has revealed himself in his creation.

<div align="right">

—John Stott

</div>

<div align="center">

* * *

</div>

The word *parable* comes from a combination of two Greek words: *para,* meaning "alongside of" and *ballo-* "to throw," *para + ballo*: "to throw alongside of."

Jesus taught by telling familiar stories of everyday life. He threw everyday stories out to his disciples to help them understand spiritual reality that would have otherwise remained hidden.

In much the same way, I am convinced that *physical nature* itself was conceived and designed to help give us knowledge of the truth of God's existence. The tangible realities

and the unseen physical laws of creation direct us to a sure knowledge of the transcendent and eternal truth about God, his being, his attributes, his care, his beauty, his power, and his glory. *Nature* is, in fact, "a visual disclosure of the invisible God," *thrown alongside* to give us a heightened awareness of God's presence, truth, and direction. Nature is teeming with signs that point and whisper, "This Way...."

We are, in my opinion, living in a *physical and visible parable* designed to woo the immortal soul of man.

> How priceless is your unfailing love!
> You give them drink from your river of delights.
> For with you is the fountain of life;
> In your light we see light.
> (Psalm 36:7–9)

* * *

Take Us to the Water's Edge, Lord

Shepherd, lead us to the water,
Please, dear Father, meet us there;
Lift each eye and heart to heaven...
Lift us from the fowler's snare.

Take us to the water's edge, Lord,
Place us there on bended knee;
There clear up the muddied waters...
Help us seek You *honestly*.

Lord, in quiet, calm reflection...
Living Water, have your say;
Plant the seed of faith within us,
Sweep the fog of doubt away!

On the shoreline, in your presence
There reflected in the clouds;
Lift our vision to the heavens
Even as our heads are bowed.

LIVING WATER, QUIET THUNDER

On reaching the rocks below, all the waters flowed together in a glorious host, forming an exuberant rushing torrent which swirled triumphantly around and over the rocks. . . . Laughing and shouting at the top of their voices, they hurried still lower, down through the meadows to the next precipice and the next glorious crisis of their self-giving.

—Hannah Hurnard, *Hinds' Feet on High Places*

* * *

Water is more than just an essential, life-sustaining natural element in the physical realm of creation. Its unique properties captivate the human mind and imagination in a way that nothing else can. It thunders, it babbles, and it sings. It rains down, cascades, and ebbs and flows. It may flood in as a mighty torrent or steal in as a gentle mist.

Water cleanses, purifies, and refreshes. It restores, and it revives.

Water has the power to calm and to soothe. By its very nature, water invites meditation and reflection in a way that is both mysterious and profound. Water can inspire and intrigue both artist and philosopher, and it is just as likely to enthrall and excite the smallest child. At every level of human experience, water is able to please and satisfy us deeply, and we are drawn inexorably to it.

I am convinced that water is an elemental spirit-persuader, a natural *truth-bearer* from the very heart and mind of God. Indeed, water seems to be a *signpost* directing us

(God's image-bearers) to the true Eternal Light and source of Life. Water seems to have an intrinsic quality beyond the merely physical that is able to draw the human soul and spirit *through* wonder toward ultimate meaning and divine communion. It is a medium that God, in his infinite wisdom, has created and placed in our midst to help direct the human heart and soul homeward....

* * *

The voice of the LORD is over the waters, the God of glory thunders, the LORD thunders over the mighty waters.

—Psalm 29:3

* * *

Lead us, Lord, to the rushing waters,
Help us to hear your quiet thunder,
Help us follow,
Help us heed.
Give us the grace to wonder, to reflect, to listen,
And to drink deeply at this spring.
Living water, quiet thunder,
Restore our souls.

* * *

Then will the eyes of the blind be opened
and the ears of the deaf
unstopped.
Then will the lame leap like a
deer,
and the mute tongue shout for joy.
Water will gush forth in the
wilderness
and streams in the desert.
The burning sand will become a pool,
the thirsty ground bubbling springs.

—Isaiah 35:5–7

CAESAREA PHILIPPI

In the Promised Land of ancient Israel, natural, self-replenishing underground springs were known as "living waters."

* * *

Jeremiah prophesied against the spiritual adultery of his day. He saw corruption at the temple in Jerusalem, and it broke his heart. Worship there had become stagnant and muddied. It was corrupt, polluted, and poisoned by pagan-inspired apostasies and the traditions of man. Jeremiah saw that his brethren had "dug their own cisterns" (Jeremiah 2:13) and had forsaken the God of Abraham and Moses, the *true* spring of Living Water.

* * *

In the Gospel of Matthew (chapter 16), we are told that Jesus took his disciples to a place called Caesarea Philippi (or, as it had been known formerly under Greek domination, Paneas). It was a strikingly beautiful setting, a place situated on the southwestern slopes of Mount Hermon in northern Israel in an area near what is today the Syrian border. There, at the base of a hundred-foot rock-wall cliff was a cave, and from the cave, an underground spring poured forth her "living waters."

Caesarea Philippi had long been a center for pagan temple worship, and it continued to be so in Jesus's day. Water spilled out of the cave and ran alongside the elaborate temple-complex area. The pagan "worship services" at Paneas were notoriously licentious and lascivious. The high priests and priestesses who presided there were often temple prostitutes. Fertility rites of unrestrained sexual activity had become the main attraction of the "religious" services there. The pagan revelers were entranced and enthralled. The "god" worshipped at Caesarea Philippi was Pan. He was, they believed, the god of nature, the god of baser instincts, the god of the underground. The temple at Paneas was a *very* popular draw.

Self- and sensate-centered worship never goes out of style.

Jesus brought his disciples to Caesarea Philippi (i.e., to "the gates of hades") for a purpose. There the stage was set. With the backdrop of the towering rock wall and the underground spring water gushing from its base, there in the midst of Pan-ic-driven revelry and lust, Jesus asked his disciples the very simple yet profoundly important question, "Who do people say the Son of Man is?"

"Simon Peter answered, 'You are the Christ, the Son of the living God.'" (Matthew 16:13, 16).

It was a very teachable moment at a *very* instructive place. Peter, of course, got the answer right. He was beginning to understand that Jesus was not only the Messiah foretold and promised in the Law of the prophets, but that Jesus was…in fact… Incarnate God. Truth began to dawn on Peter that Jesus was himself the *true source* of the "living water" and was himself the rock from whom *all* blessings flow.

* * *

Take Us, Father, to the Fountain

Father, teach us how to know You…
How to find You in this place,
Help us taste true Living Water,
Lord, that springs from boundless grace.

Give us wisdom in this desert,
Pan-ic land of sensate lust,
May the flesh give way to Spirit,
So your Word, Lord, we will trust.

In the land of idol pleasure,
Sin imprisons everyone.
Father, wash us in this water…
In the blood of Christ, your Son.

Take us, Father, to the fountain,
To the spring that never ends,
Where the fount of life eternal
Promises to heal and mend.

* * *

If anyone is thirsty, let him come to me and drink. Whoever believes in me, as the Scripture has said, streams of living water will flow from within him.

—John 7:37–38

DID YOU HEAR THE HARP OF HEAVEN?

In the beginning God created the heavens and the earth. Now the earth was formless and empty. The darkness was over the surface of the deep, and the Spirit was hovering over the waters. And God said, "Let there be light."

—Genesis 1:1–3

* * *

Christians understand that "in the beginning, God" conceived and spoke the universe into existence through the power of the Holy Spirit. In the process, the Spirit of God is said to have "hovered" over the waters in this primal act of creation, an act initiated by the spoken Word.

The Hebrew word (*rachaph*) that is translated *hover* in Genesis 1:2 means "to move" or "to shake" or "to flutter." In my mind, I imagine a relaxed, *sound*-related, and Word-induced vibrational flutter, a purposeful act designed by the mind of God to stir the formless "deep" to creation—light and then to life…..

In the New Testament Gospel of John, the apostle tells the reader more about this Creator:

In the beginning was the Word [*Logos/Reason*], and the Word was with God, and the Word was God. He was with God in the beginning. (John 1:1–2)

In John's first epistle to fellow believers, the apostle further identifies this Creator (the *Logos, this Reason)* to be Jesus...God Incarnate, Spirit and Word made flesh....the Christ.

That which was from the beginning, which we have heard, which we have seen with our eyes, which we have looked at and our hands have touched—this we proclaim concerning the Word of Life. (1 John 1:1)

The Word, the sound, the water......creation.

* * *

In the Gospel of Mark, we are told that Jesus, the Word made flesh, went out onto harp-shaped Lake Chinnoreth (from the Hebrew word *kinnor* meaning "harp") to begin drawing people into the ark of the New Covenant....and, ultimately, into the "new creation":

Again Jesus began to teach by the lake. The crowd that gathered around him was so large that he got into a boat and sat in it out on the lake, while all the people were along the shore at the water's edge. He taught them many things by parables, and in his teaching said: "Listen! A farmer went out to sow his seed." (Mark 4:1)

Did You Hear the Harp of Heaven?

Did you hear the harp of heaven
On the lake, my friend, today?
Did the Spirit hover softly
O'er the water, did you say?

Did He speak of *new c*reation?
Did your heart within you leap?
Did you hear the Spirit calling
O'er the surface of the deep?

Did your spirit tremble slightly?
Did vibrations move your soul?
Did the Holy Spirit call you
When you heard the truth unfold?

Was there blessing by the water?
Did new life begin to grow?
Could you hear the strings of heaven
As the Son began to sow?

Did He pluck the strings of wonder
At the water's edge that day?
Did He strum the chords of glory?
Was your sin there washed away?

Did the strains of mercy move you
Ever closer there to Him?
Did the Spirit overwhelm you?
Did the world grow strangely dim?

When He spoke of new creation
And He taught you truth sublime,
Did you see the royal Bridegroom
Who will love you for all time?

Did the love notes of Messiah
And your longing heart collide?
Did you answer his proposal?
Did you there become his bride?

* * *

For God so loved the world that He gave His one and only Son,
that whoever believes in Him shall not perish
but have eternal life.

—John 3:16

Epilogue

Blessed are those who hunger and thirst for righteousness,
for they will be filled.

—Matthew 5:6

* * *

As marvelous as the teeming beauty of nature may be here and now and no matter how often we may glimpse creation's sublime glories here on earth, I am convinced that these earthly gems and sensual treasures will pale to insignificance when compared to the joys and pleasures and wonders that are reserved for us when we will at last drink from the river of the water of life described in the final chapter of the Bible (Revelation 22:1). I am certain that our glorified bodies and senses will simply be overwhelmed by the unsurpassed beauty that we will enjoy in the eternal presence of God.

And we rejoice in the hope of the glory of God . . . And hope does not disappoint us, because God has poured out his love into our hearts by the Holy Spirit, whom he has given us. (Romans 5:2–5)

Father, may the intricacies of your handiwork in creation remind us of the beauty of your redemption plan. May we be reminded of your love for us and the price that was paid to wash our sins away. Help us to sense your presence on the shoreline of our lives and then give us the ability to hear your still, quiet voice above the hot wilderness wind that so often threatens to overwhelm us. Father, as we reflect, may we sense your glory, your holiness, and your righteousness.

May we *thirst* for You and seek You earnestly.

Help us to recognize in both heart and mind that Jesus is Lord (see Romans 10:9). Give us the wisdom and the grace to confess our sin(s) and to honestly and *sincerely* repent.

Remind us, Father, that the floodgates of your mercy and love were sprung open at the cross of Calvary. Baptize us there in the truth of what You have accomplished for us and what we could never have done for ourselves. By the power of your Spirit, Lord, give us faith to know that "it is finished." Fill us to overflowing with the knowledge that in Christ we are made *truly* clean and acceptable in your sight. Help us know without a doubt what the women at the garden tomb joyfully discovered: He's alive!

Help us, Father, to trust your Word. Bless us, Lord, through faith in the promised risen Christ, Son of Man and Son of God.

Help us to recall the words of Jesus:

> For God so loved the world that he gave his one and only Son, that whoever believes in him shall not perish but have eternal life. For God did not send his Son into the world to condemn the world, but to save the world through him. Whoever believes in him is not condemned, but whoever does not believe stands condemned already because they have not believed in the name of God's one and only Son. This is the verdict: Light has come into the world, but people loved darkness instead of light because their deeds were evil. Everyone who does evil hates the light, and will not come into the light for fear that their deeds will be exposed. (John 3:16–19)

Father, quench our dying thirst. As we stand here at the edge of glory, give us the grace to step out of this darkness and into the eternal light of heaven.